a little book for fathers

(and the people who love them)

liz climo

HarperCollins*Publishers*

HarperCollins*Publishers*
1 London Bridge Street
London SE1 9GF

www.harpercollins.co.uk

HarperCollins*Publishers*
1st Floor, Watermarque Building, Ringsend Road
Dublin 4, Ireland

First published by Flatiron Books
This UK edition published by HarperCollins*Publishers* 2021

1 3 5 7 9 10 8 6 4 2

© Liz Climo 2021

Liz Climo asserts the moral right to be
identified as the author of this work

A catalogue record of this book is available from the British Library

ISBN 978-0-00-843644-5

Designed by Steven Seighman

Printed and bound in Latvia

MIX
Paper from
responsible sources
FSC™ C007454

This book is produced from independently certified FSC™ paper to ensure responsible forest management.

For more information visit: www.harpercollins.co.uk/green

For Colin and Bob

you're dad.

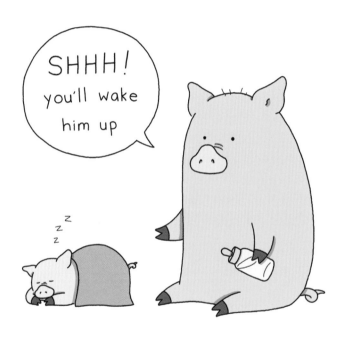

Oops, sorry. I'll move this to the next page.

Okay, where were we . . .

You're dad! Or, maybe you aren't – but you probably know a dad, or possibly have a dad. Maybe you love a dad, or have lost a dad. Either way, if this book is in your hands, the word 'dad' probably means something to you, and if someone gave it to you, then you must be pretty special. (And if you're buying this book for yourself, clearly you have excellent taste.) Regardless of how you got this book, I'm so happy it's yours.

I'm not sure if I should admit this, but you seem cool, so here goes: This book was actually a little hard for me to start writing. I had just finished another book called *You're Mum* and knew I wanted to do a follow-up book for dads. The first book came pretty naturally to me. From start to finish, I always had a pretty clear idea about what I wanted to say. You see, I lost my mum in my early twenties, and I've had years to process my feelings about what she meant to me and how hard it was to lose her. Words of love, loss, acceptance, and gratitude poured out of me pretty naturally – and the book ended up being a love letter not just to mums but to all great parents. So, when I started working on this book, I felt stumped. It's not that I don't have a good relationship with my dad (I do – hi, Dad!), but I wondered how I could make this book different from the first one.

How are dads different from mums anyway? Are they? And what about families that don't have dads? Would I be excluding those families by writing this book? I felt like I had inadvertently backed myself into a corner by writing the first book and had no clue what I wanted to say with this one.

So, I started thinking about what it means to be a dad. The dads I grew up watching on TV were usually men married to women, who were good at fixing things, oftentimes masculine, sometimes clumsy, or maybe even surly. They were the long-suffering breadwinners, who ended each day with a beer between their knees and a football game on TV. Some dads are like that, sure! But this stereotypical notion of a dad, of course, doesn't represent all dads. I decided I wanted this book to show all the different ways a person can be a dad. So, I started thinking about the dads in my life. I thought about my own dad, an introverted, hardworking businessman who loves singing only the high notes in songs (think 'Stay' by Maurice Williams and the Zodiacs) and who once dressed up as Tinker Bell for Halloween (my mum was Peter Pan). My brother, who loves playing and watching sports and is also an incredible baker (he recently baked doughnuts for his wife as a thank-you after she fixed their broken radiator). My husband,

who always takes the time to listen to, connect with, and understand our daughter, whether it be shooting hoops with her in our yard or having his nails painted by her. I have friends whose families include two loving dads and others with children who don't have someone in their family they call 'dad' at all. I know people with children from previous relationships, with partners who have forged meaningful parental relationships with the children in their lives. I thought about all these different types of dads and families and decided I wanted to honor the one thing they all have in common: the unwavering love and support of a good parent and all of the beautiful ways that's represented within different families.

The idea of the 'traditional' family is evolving, and it's a wonderful thing. Whether you're a beer-drinking, football-watching dad or a fingernail-painting, doughnut-baking dad (or both!), a fun uncle, a dear friend to someone with kids you adore, or even if you're not a dad at all, in the traditional sense, if you are a parent or someone in a parental role, your love and attention means everything to the people who look up to you. Because when you're dad – no matter what that looks like – you are so loved.

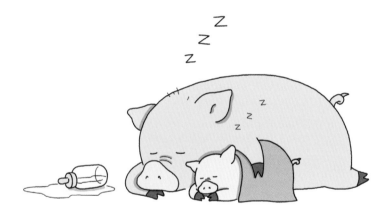

Thanks. I hope you like it.

Liz

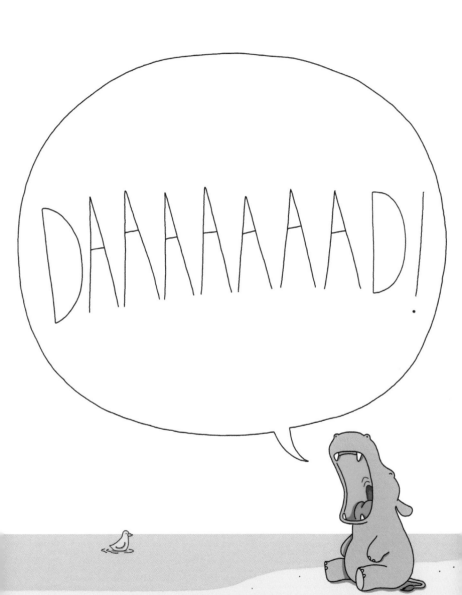

Oh, hello!

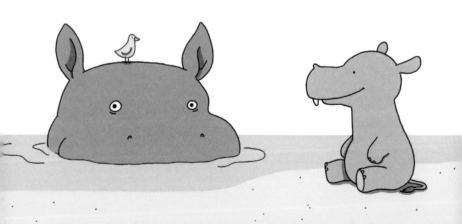

Now that I have your attention . . .
ahem . . .

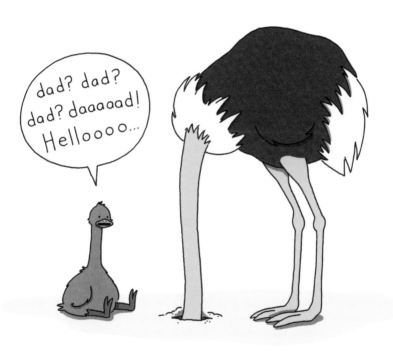

You must be dad!

You're probably pretty busy.

(Okay, well, the rest of you dads probably are.)

So, let's cut to the chase.

Being a dad is pretty great.

Maybe you already know this.

Maybe you will soon.

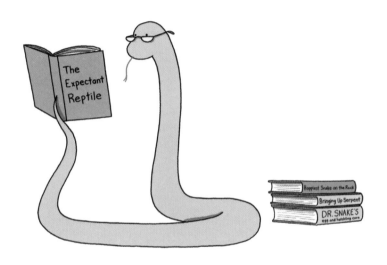

Maybe you've been preparing
for a long time.

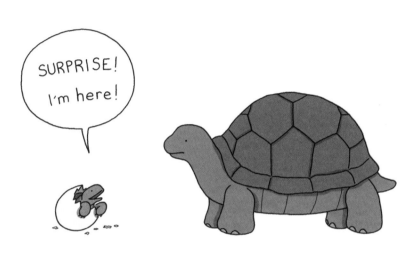

Maybe not.

But if you're about to
become a dad

then it's time to get serious

because fatherhood is
serious business.

You might feel a
little anxious.

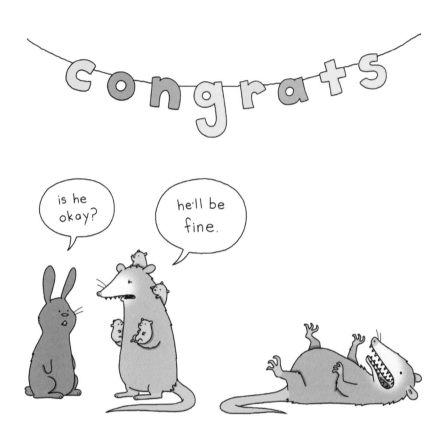

Maybe even a bit scared.

There's a lot to prepare

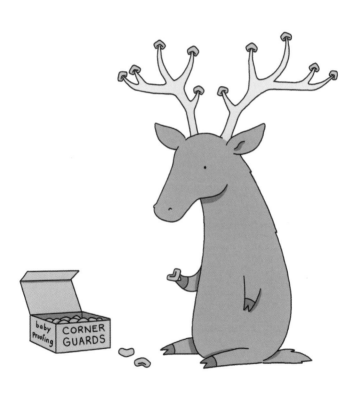

and plan.

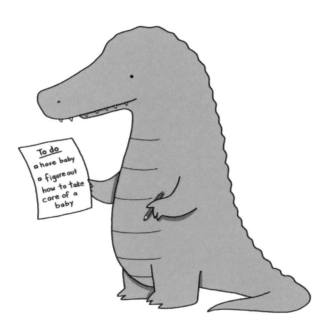

After all, becoming a dad is a huge responsibility.

But, it's worth it.

Now the real fun begins.

Bringing a new baby home
is a big adjustment.

Your routine might change a bit.

Okay, more than a bit.

It can get messy

and loud.

You'll get tired.

Um, hello? I'm talking to you.

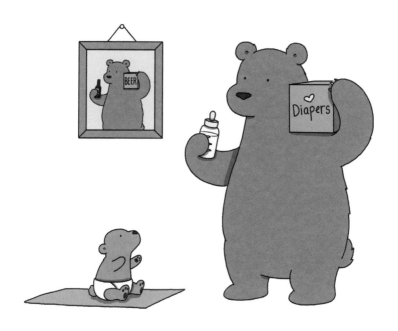

Your fun, carefree days may be
in the past . . .

. . . but, hey! Being a dad can be pretty fun, too.

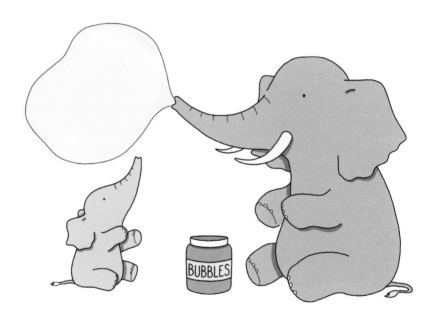

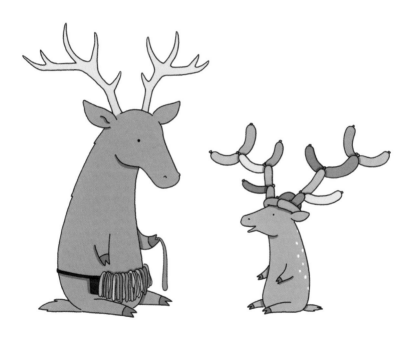

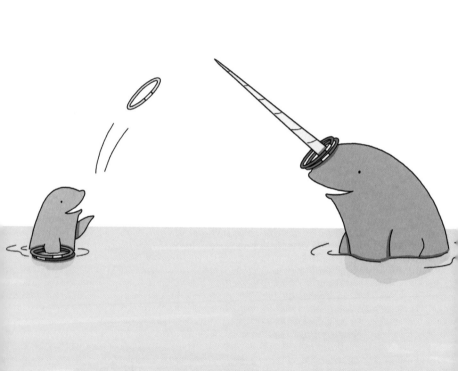

Sure, it might not look
the way you thought.

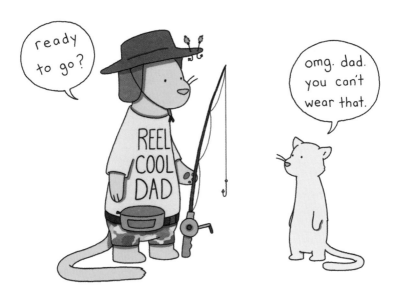

Or maybe it's even better
than you expected.

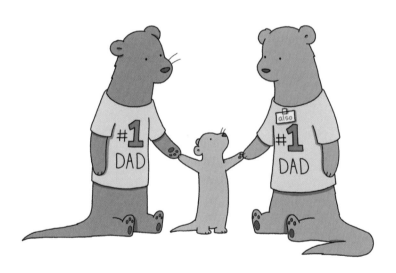

Maybe you have a partner

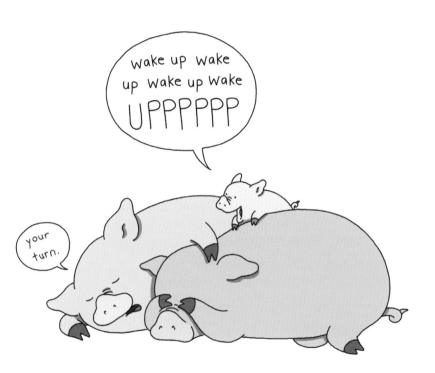

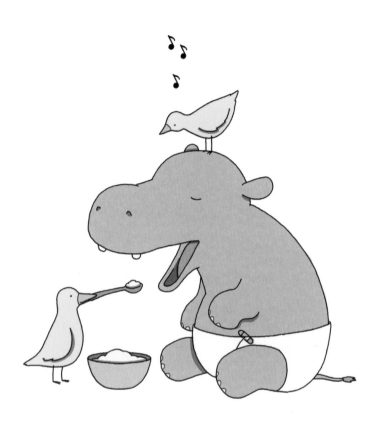

or the help of family and friends

or maybe it's just the two of you.

You might be a working dad

or maybe your work is
in the home.

Maybe you've been with him
since the beginning

or met later on.

Maybe you're following in your
dad's footsteps

or forging your own path.

No matter how you got here,
there's someone who looks
up to you now.

So, try not to mess it up.

Just kidding! You'll make some mistakes, of course.

Maybe more than a few.

But you'll do your best

and you'll learn some stuff
along the way.

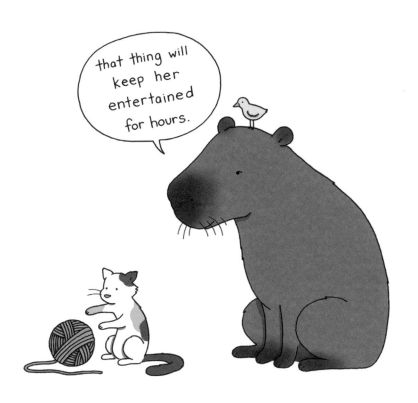

There are games to play.

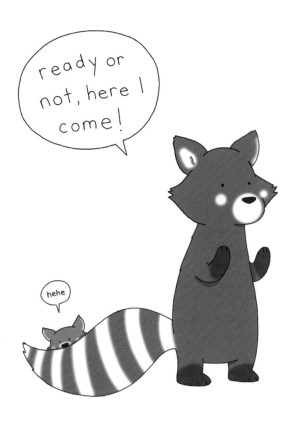

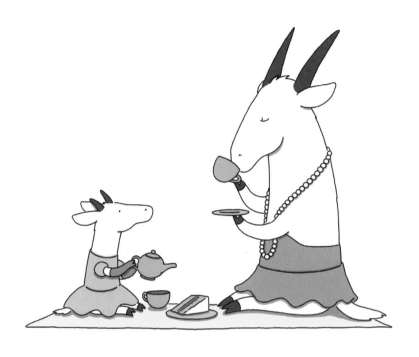

Tea parties to have.

Songs to sing.

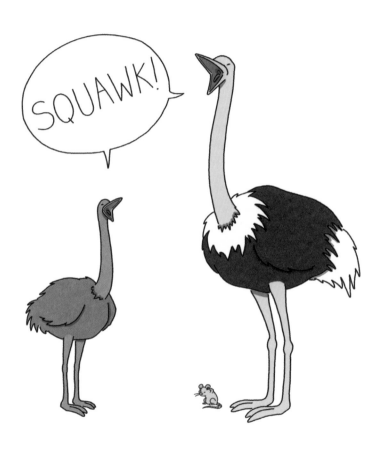

Problems to solve.

Lessons to learn.

...and what will you do differently the next time you find a can?

I won't stick my nose in it

And great adventures ahead.

After all, there isn't an instruction
manual for parenting . . .

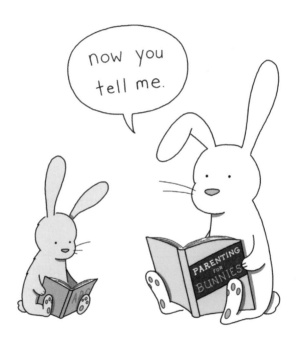

. . . and dads wear many hats.

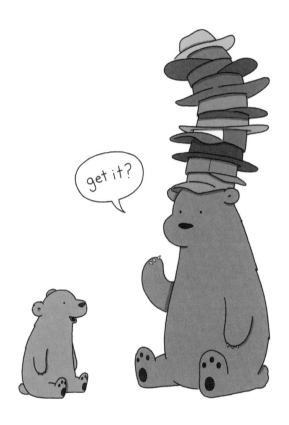

(Yes, we get it.)

You're not just a dad.

You're also a magician.

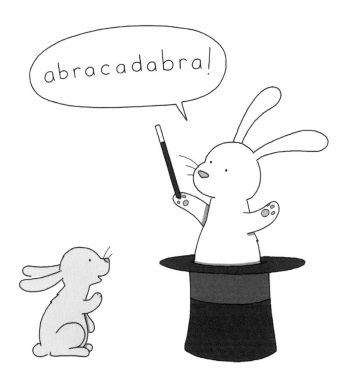

A hairdresser.

A teacher.

A chef.

A manicurist.

A jungle gym.

A chair.

And a friend.

Maybe you're brave.

Maybe you aren't.

Either way, you're still her hero.

Maybe you're silly.

Maybe you're serious.

Either way, you're still his favourite storyteller.

"NOT BY THE HAIRS ON MY CHINNY CHIN CHIN" said the pigs!

Maybe you're handy.

Maybe not.

Either way, you still always know
how to fix things.

The days may feel long,
but they'll go by in a flash.

Remember to stop and
take it all in.

Because between all the laughter

and the tears

the mundane

and the milestones

are little moments of magic.

You'll want to remember those.

Remember when she used to
look up to you?

She still does.

Sure, they might need you less.

Distance might keep you apart.

Your roles may even reverse.

But the love you share is forever.

Because to the world,
you're dad . . .

but, to them . . .

you're everything.

So, yeah . . .
you've got some pretty
important work to do.

Like, super DUPER important.

No pressure.

Hey, are you still listening?

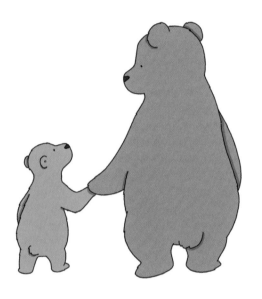

Good.

Acknowledgments

First off, I want to thank *you*! Whether you're holding this book because you bought it for yourself or for someone else or received it as a gift – thank you for the support. To my outstanding agent, Kathleen Ortiz, and everyone at New Leaf Literary for their awesome work throughout the years – thank you! You are the very best. To Sarah Murphy, Sydney Jeon, and everyone at Flatiron Books, thank you for the beautiful work and for giving me the opportunity to create both this book and also *You're Mum*. To my family and friends for their continuous love, support, and encouragement. To the people in my life who inspired this book, whether you're a dad, a mum, or someone who fills that role – thank you for everything you do. And finally, to super dad and grandpa, John Mosseman Lewis – this book was created in loving memory of you.

About the Author

LIZ CLIMO is a cartoonist, children's book author, illustrator, and animator. She grew up in the San Francisco Bay Area and moved to Los Angeles after college to work as a character artist on *The Simpsons*. She is the author of the Rory the Dinosaur series, *You're Mum*, *The Little World of Liz Climo, Lobster Is the Best Medicine*, and *Best Bear Ever!* Her books have been translated into ten languages and have sold more than 2.25 million copies worldwide. She lives in Los Angeles with her husband and daughter.

www.thelittleworldofliz.com